YELLOWSTONE

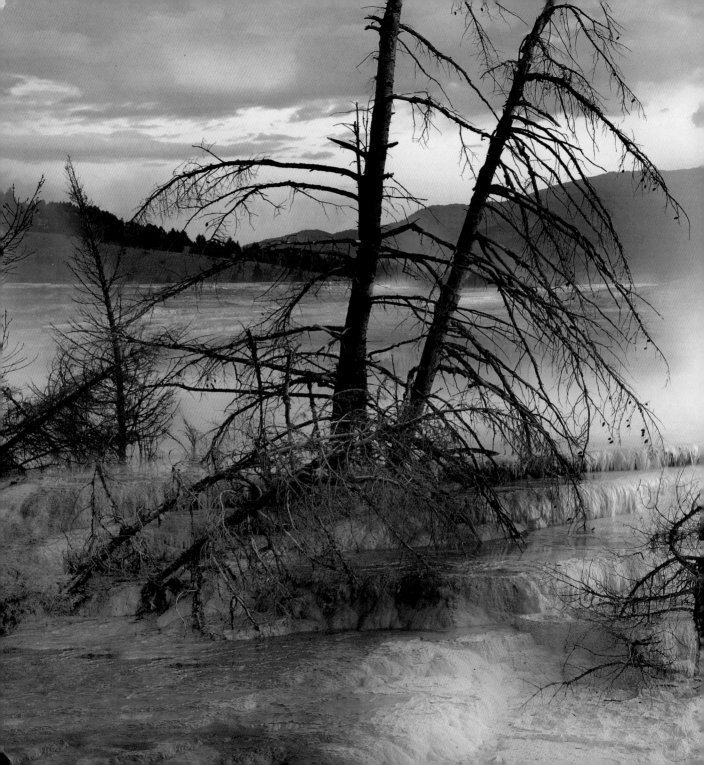

YELLOWSTONE

Photographs by
TIM FITZHARRIS

Introduction by
TRACY C. READ

FIREFLY BOOKS

A Firefly Book

Published by Firefly Books Ltd. 2011

Text copyright © 2011 Firefly Books Ltd.
Photographs copyright © 2011 Tim Fitzharris

First printing

Publisher Cataloging-in-Publication Data (U.S.)

Read, Tracy C.
 Yellowstone National Park / Tracy C. Read ; Tim Fitzharris, photographer.
[64] p. : col. photos. ; cm.
Summary: A photographic journey of Yellowstone National Park's plants and animals, landscape and major geological sites.
ISBN-13: 978-1-55407-786-1
ISBN-10: 1-55407-786-9
1. Yellowstone National Park – Pictorial works. 2. Natural history – Yellowstone National Park. 3. Natural history – Yellowstone National Park – Pictorial works. I. Fitzharris, Tim. II. Title.
508.787/52/0222 dc22 QH105.W8R43 2011

Library and Archives Canada Cataloguing in Publication

Read, Tracy C
 Yellowstone National Park / Tracy C. Read ; Tim Fitzharris, photographer.

ISBN-13: 978-1-55407-786-1
ISBN-10: 1-55407-786-9

1. Yellowstone National Park--Description and travel. 2. Yellowstone National Park--Pictorial works. I. Fitzharris, Tim, 1948- II. Title.

F722.R38 2011 978.7'52 C2010-907372-X

Published in the United States by
Firefly Books (U.S.) Inc.
P.O. Box 1338, Ellicott Station
Buffalo, New York 14205

Published in Canada by
Firefly Books Ltd.
66 Leek Crescent
Richmond Hill, Ontario L4B 1H1

Printed in China

The Publisher gratefully acknowledges the financial support for our publishing program by the Government of Canada through the Canada Book Fund as administered by the Department of Canadian Heritage.

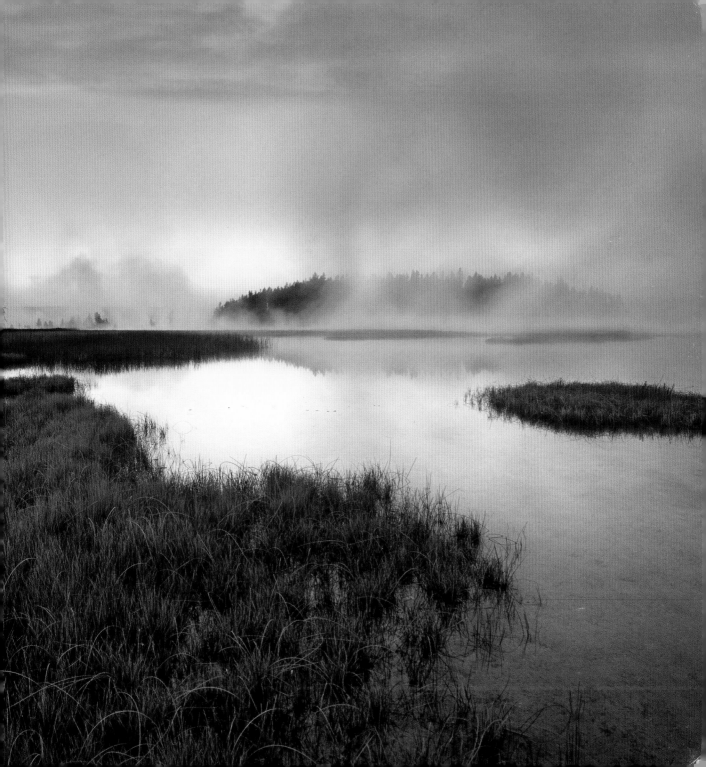

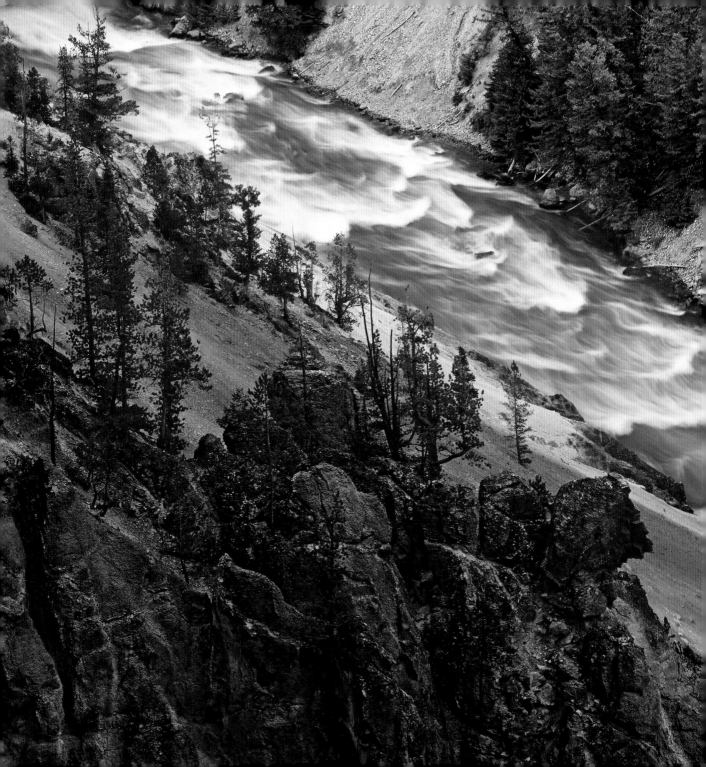

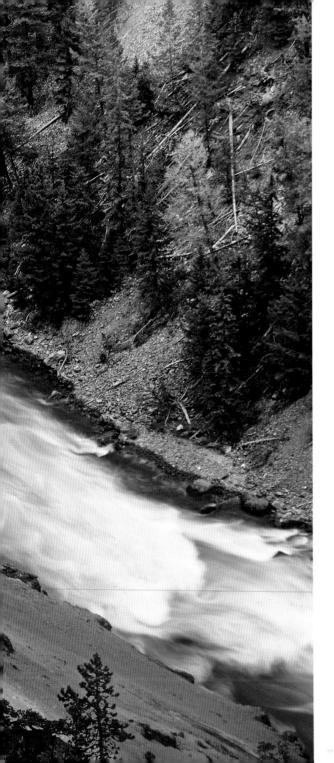

YELLOWSTONE

AN INTRODUCTION

On March 1, 1872, the U.S. Congress changed the course of American environmental and recreational history when it passed a bill to establish Yellowstone National Park. This resounding support for the preservation of a wilderness area made official what anyone who had visited the region already knew: Here was a vast piece of land so spectacular and so rare that it demanded special consideration and protection.

The inaugural park in the country's National Park System, Yellowstone continues to hold a distinct place in the hearts and imaginations of people all over the world. "A thousand Yellowstone wonders are calling, 'Look up and down and round about you!'" wrote John Muir, a wilderness-preservation advocate and the founder of the Sierra Club, in 1909. In the early years of the 21st century, American travel writer Tim Cahill echoed the sentiment, affectionately describing Yellowstone as "an embarrassment of wonders."

LEFT: The reddish hues of the canyon walls that rise roughly 1,000 feet above the Yellowstone River are caused by the oxidation of iron compounds in the soil.

These two claims, made almost a century apart, can be supported by numbers alone. Yellowstone encompasses 2.2 million acres, the majority of which lies within the state of Wyoming, with its western and northern borders dipping into Idaho and Montana. Scattered across the park are half of the world's total active thermal features — geysers, hot springs, mud pots, steam vents and terraces — some 10,000 in all. Its more than 300 geysers represent two-thirds of the Earth's entire geyser catalog. Each feature is animated by groundwater that has been superheated by molten magma rising from the Yellowstone hot spot. Scientists claim that this hot spot is a mere three to eight miles beneath the Earth's crust.

As if its dazzling array of waterworks were not enough, Yellowstone is also home to a showcase of other marvels. Almost 700 miles in length, the Yellowstone River is the longest undammed river in the lower 48 states. It flows tranquilly through the Hayden Valley before it is transformed into a frothing waterway that roars over two sizable waterfalls and surges along a 20-mile canyon steeply banked by multicolored 1,000-foot cliffs.

RIGHT: Roaring Mountain is located just north of Norris Geyser Basin and is named for the shrill sounds made by the active steam vents that stud the 400-foot mountain slope.

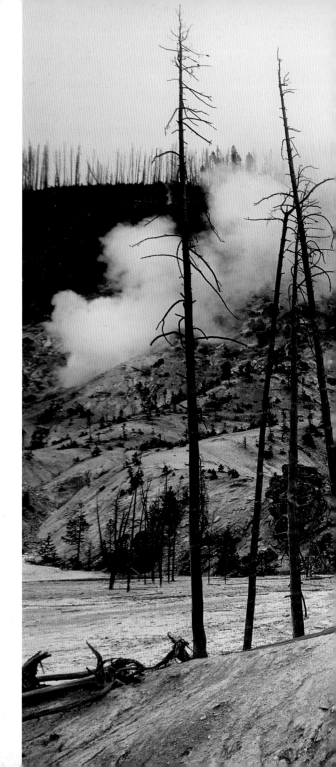

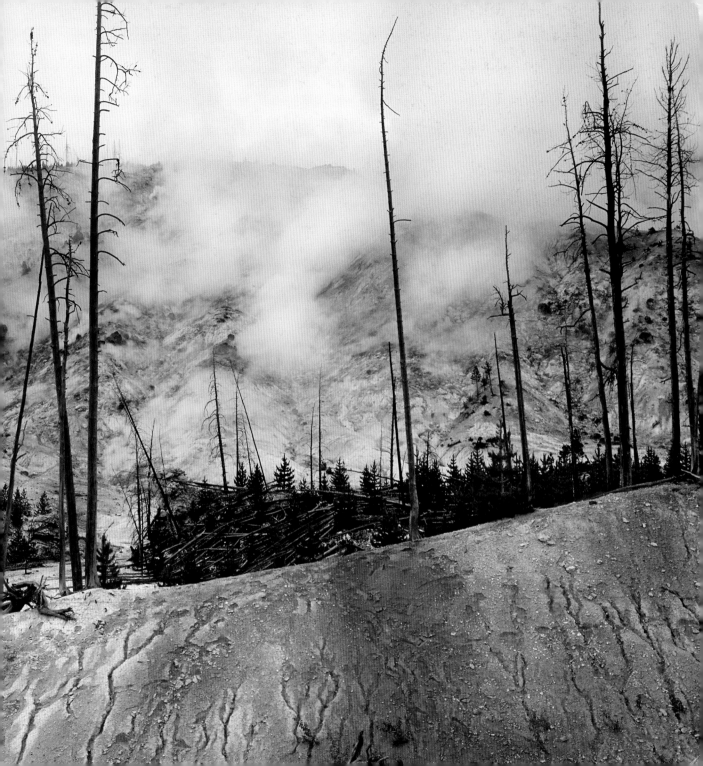

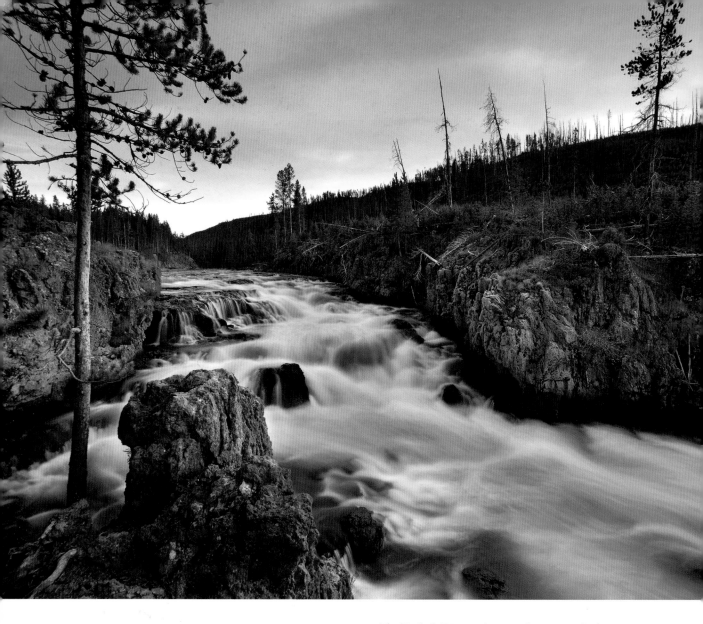

ABOVE: The Firehole River rushes over fragments of volcanic rock as it heads toward the 40-foot drop at Firehole Falls, in the southwestern corner of the park.

OPPOSITE PAGE: The decision to return the gray wolf to Yellowstone in 1995 restored a keystone species to the park.

More than 40 mountain peaks in the Yellowstone area reach heights greater than 10,000 feet. Subalpine forests color the mountain ranges that ring the park as well as the mountain slopes within the park's boundaries, while the stunted stumps of petrified trees in the Lamar Valley are evidence of a forest that covered the region 55 million years ago.

Hundreds of rivers and creeks wind through lush valleys, serving as a favored grazing ground for wildlife. In the mountains, the rivers are studded with an astounding 290 waterfalls, many of them so remote that they are rarely seen by park visitors. At just over 130 square miles, Yellowstone Lake is the largest freshwater lake in the park and the largest mountain lake in North America. It is 410 feet deep in places and is covered in a layer of ice two feet thick during the park's long, brutal winters. At the same time, the water temperature at the bottom of the lake is near boiling in some areas.

Sweeping plains, wildflower meadows and flatlands characterize much of the central parkland, which provides habitat to an abundance of wildlife. Roughly 70 species of mammals, 320 bird species and assorted native fish, reptiles and amphibians make their home in Yellowstone. The ancestors of some of these animals roamed the same land thousands of years ago.

Wildfires are also an important part of the ecosystem. Most often ignited when lightning strikes the summer-dry tinder of old-growth forests and fed by a desiccated understory of needles and branches, Yellowstone's infamous infernos tear through the region, demolishing everything before them, yet leaving in their wake the adaptive seeds of future trees, ready to sprout in the fire-blackened earth.

There is no way of knowing just what its first inhabitants made of Yellowstone's living, breathing landscape. After the last glacial ice retreated over 13,000 years ago, Paleo-Indians of the Clovis culture hunted mastodons and

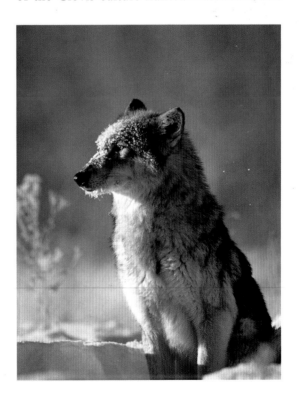

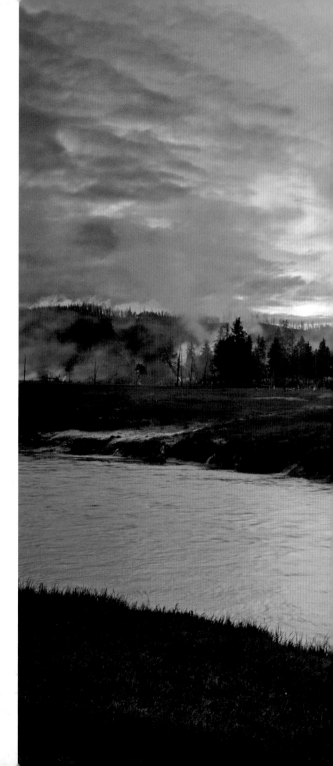

mammoths here. In more modern times, Yellowstone was settled by members of the Shoshone Nation, but others such as Crow and Kiowa lived here as well.

By the early 19th century, as European-Americans began to take a more aggressive interest in the opportunities of their newly settled continent, white men arrived to explore the region. John Colter was one. In 1807–08, after wintering in Yellowstone and investigating the Yellowstone River and its Grand Canyon and Upper and Lower falls, Colter returned to civilization and shared impressions so seemingly outlandish that nobody believed him. Mountain man Jim Bridger followed 20 years later, adding out-right lies to the lore that left the public even more uncertain about the truth concerning this simmering, bubbling, exploding terrain.

A succession of expeditions to Yellowstone followed, including that of prospectors Charles Cook, David Folsom and William Peterson in 1869, and the Washburn Yellowstone Expedition of 1870, led by Henry Washburn, the Surveyor General of Montana Territory, army escort Lieutenant Gustavus C. Doane and the man who would

RIGHT: A tributary of the Madison River, the Firehole River flows north through Yellowstone's Upper Geyser Basin. The river's quieter stretches are bordered by grasslands that attract grazing deer, elk and bison.

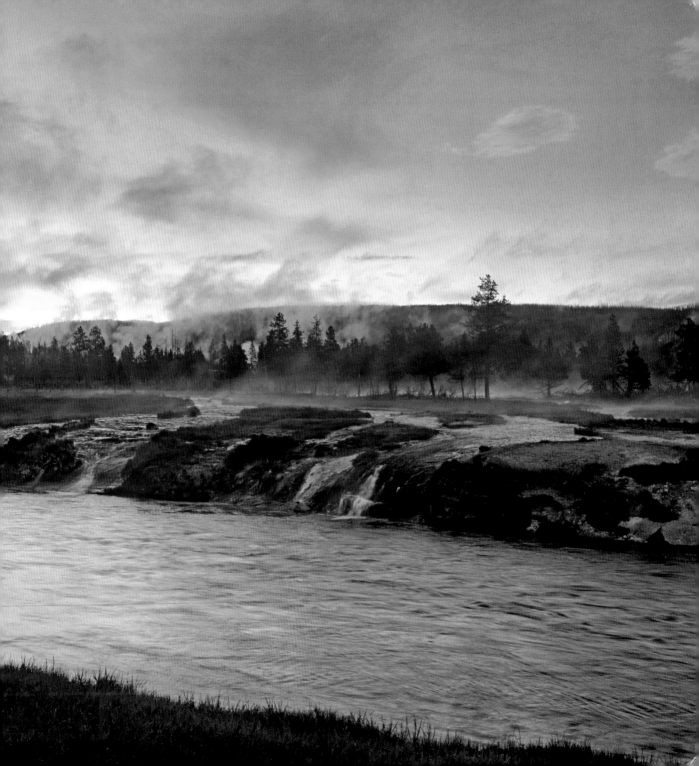

later be named the park's first superintendent, Nathaniel Pitt Langford. Even Langford's reports were received with skepticism. In a review of an article he'd published about the trip, he was accused of being "the champion liar of the Northwest," though in response, a member of the U.S. Geological Survey insisted that "Langford did not dare tell one-half of what he saw."

Geologist Ferdinand V. Hayden's expedition followed in 1871. Thanks to Hayden's technical assessment and the contributions of frontier photographer William Henry Jackson and landscape painter Thomas Moran, Hayden's group returned with the hard factual and visual evidence that at last dispelled the public's long-standing doubts about Yellowstone.

Indeed, it was Hayden who climbed 10,243-foot Mount Washburn and, gazing south over the landscape, realized that he was looking down at "one vast crater made up of thousands of smaller volcanic vents and fissures out of which the fluid interior of the earth, fragments of rocks and volcanic dusts were poured in unlimited quantities."

Hayden was describing the Yellowstone caldera, a volcanic crater formed during three monumental eruptions, the first of which occurred after the continent drifted over the Yellowstone hot spot roughly two million years ago. The second took place 1.3 million years ago, while the third shaped Yellowstone's modern landscape 640,000 years ago. These eruptions, and many more minor ones, threw up mountain ranges and produced lava flows that left a tough rocky layer over much of today's park. After the molten rock, massive sheets of glacial ice, buried most of the Yellowstone region. Over thousands of years the glaciers compressed, sculpted and smoothed the lakes, rivers and mountains of today's Yellowstone National Park, leaving behind much of the soil in which its plants and forests thrive as well as the countless cracks, creases and channels in the Earth's surface that help define the park.

The passionate work of geologists, conservationists, naturalists and park rangers has taught us much about how this wondrous place came to be. But encountering its inhabitants, hiking its backcountry and experiencing its mysterious rhythms firsthand may offer the best possible insurance that, if the Earth's natural forces cooperate, Yellowstone National Park will still be here for generations to come.

RIGHT: Sitting on limestone bedrock north of the Yellowstone caldera, the Mammoth Hot Springs Terraces are fed by water that flows along underground fault lines running north from Norris Geyser Basin. The superheated limestone-saturated water cools at the surface and accumulates as a mineral called travertine, adding new rock each day.

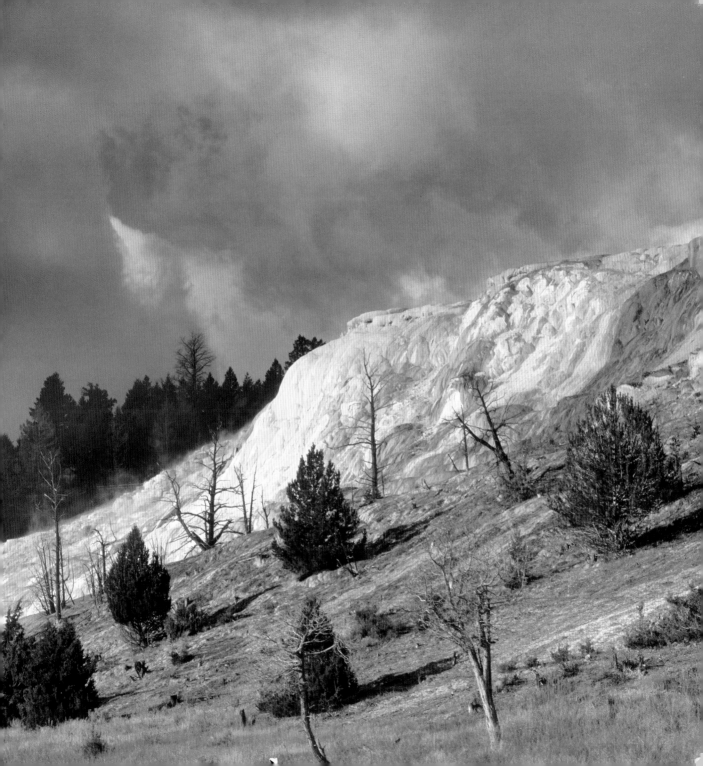

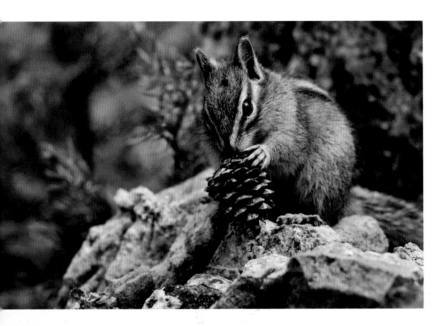

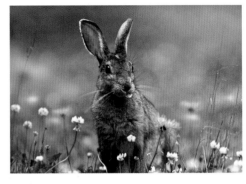

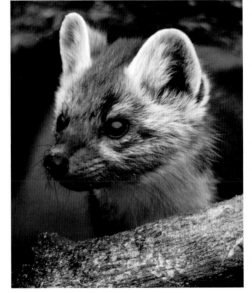

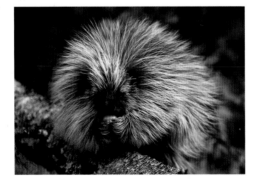

CLOCKWISE FROM TOP LEFT: Among some 70 mammals that make their home in the park's forests and meadows are the least chipmunk, snowshoe hare, American marten and porcupine.

OPPOSITE PAGE: A mature bull moose grazes on aquatic plants sprouting from the river bottom.

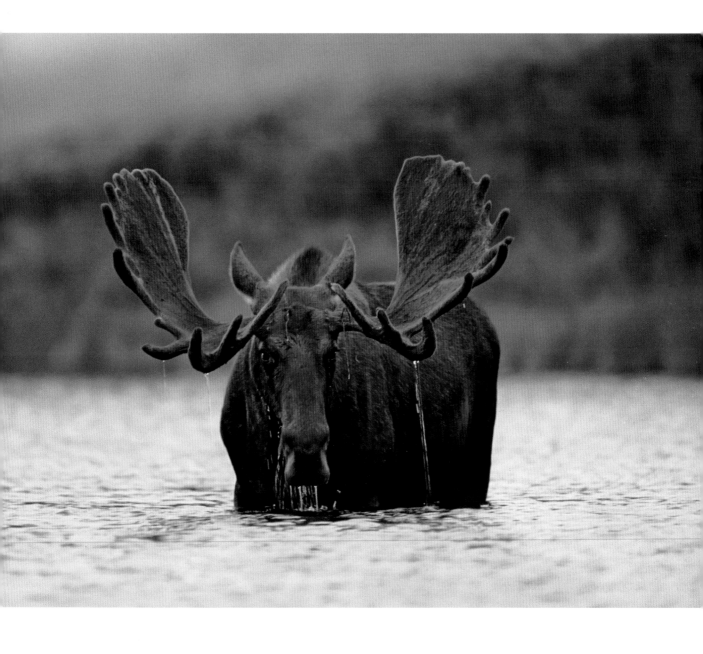

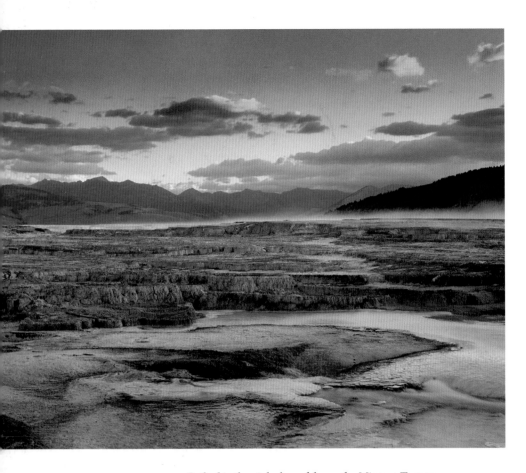

ABOVE AND RIGHT: Bathed in the pink glow of dawn, the Minerva Terrace — an ornate, multilayered construct of travertine — is part of the Mammoth Hot Springs' less active Lower Terraces. Travertine is initially white, but where the springs are active, it glistens with colors from the microbacteria and algae living in the water.

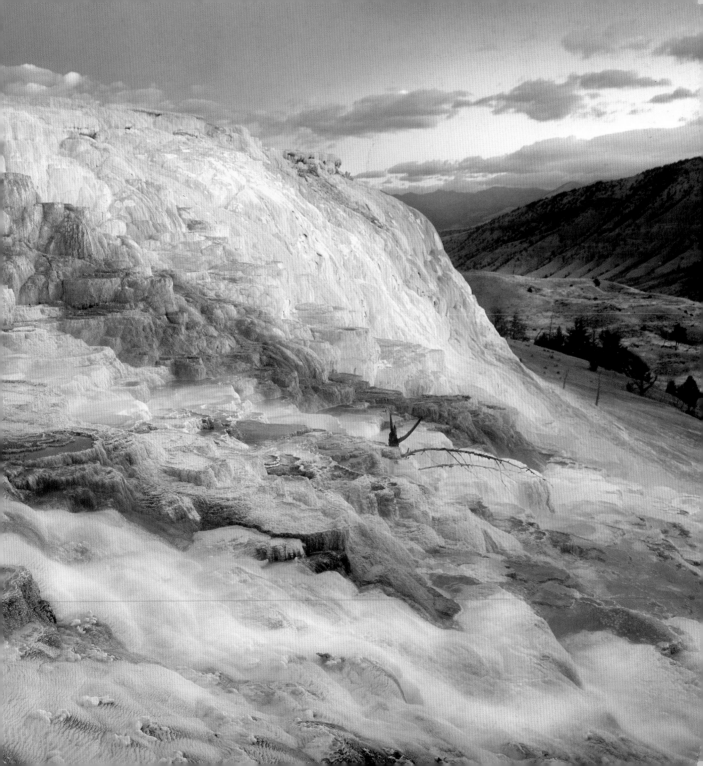

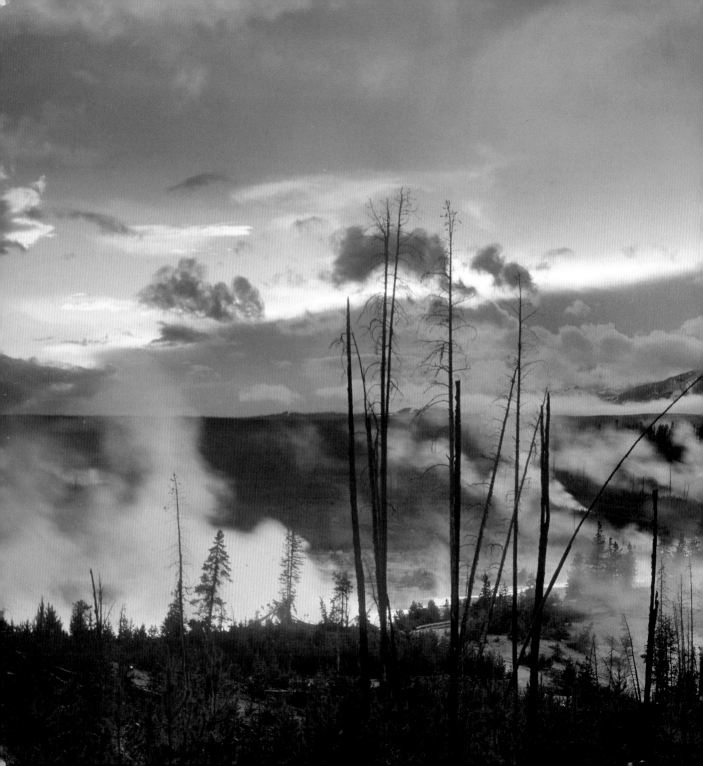

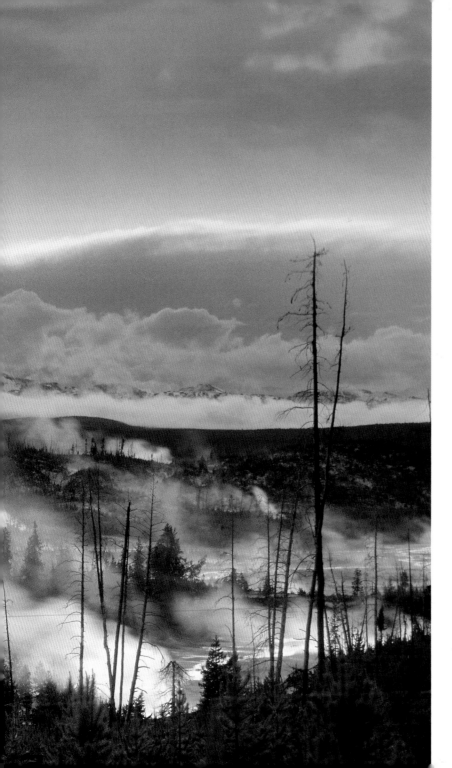

LEFT: Traces of steam drift over Norris Geyser Basin in the early-morning light. Sitting atop the intersection of three major faults that release heat from the Earth's interior, Norris is the hottest of Yellowstone's geyser basins and one of its most active.

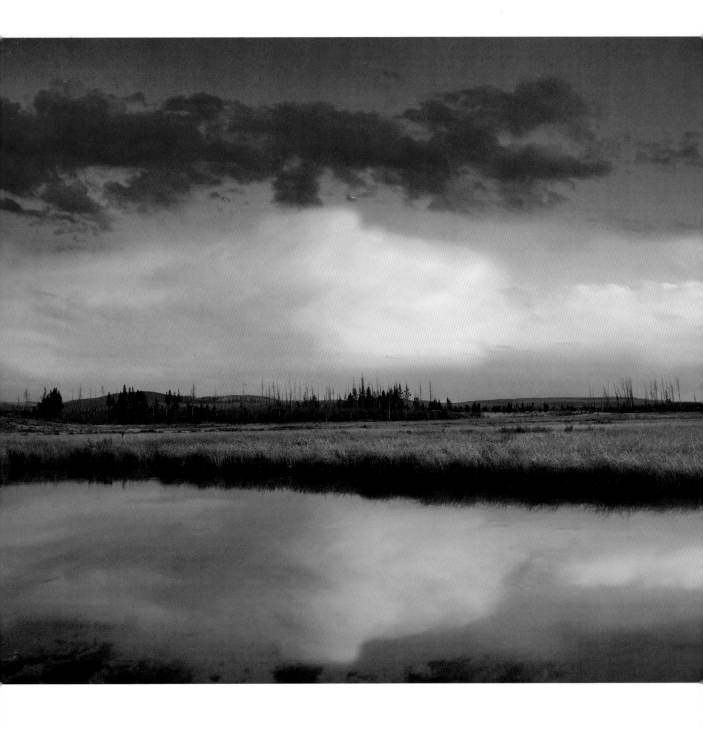

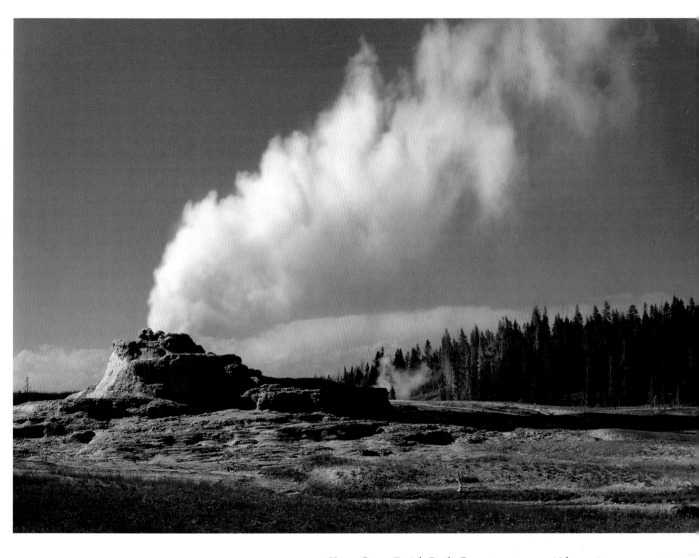

ABOVE: Upper Geyser Basin's Castle Geyser erupts every 13 hours, its column of water reaching heights of up to 100 feet.

OPPOSITE PAGE: Swan Lake, in Gardner's Hole, is an ideal site to see trumpeter swans in winter and early spring.

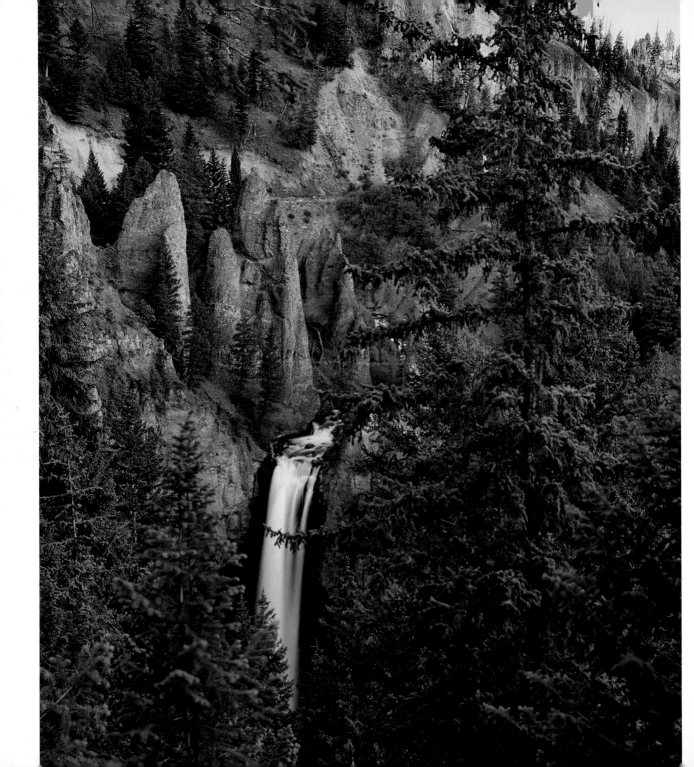

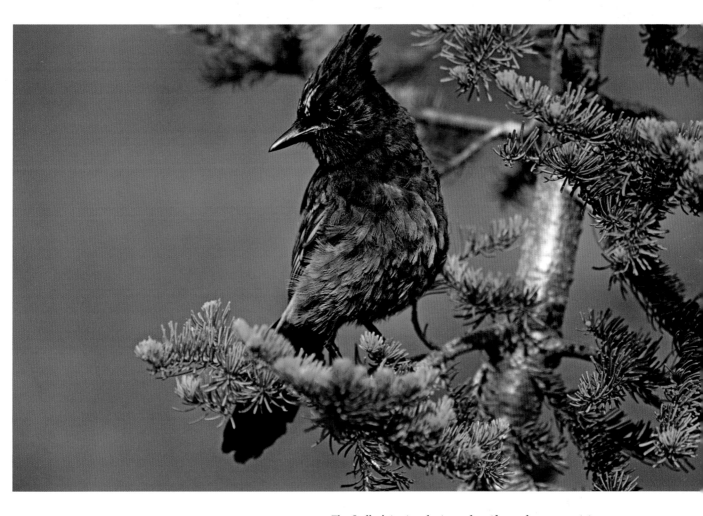

ABOVE: The Steller's jay is a denizen of coniferous forests, surviving on seeds, nuts and fruits as well as eggs, rodents and nestlings.

OPPOSITE PAGE: Surrounded by sculpture-like rocky spires, Tower Fall plummets 132 feet into a deep, tree-lined gorge, then surges a few hundred yards to join the Yellowstone River.

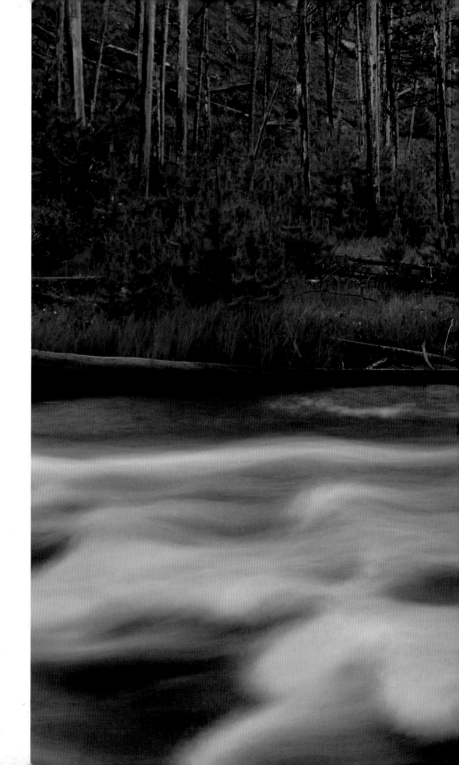

RIGHT: The Gibbon River, one of the park's favorite fly-fishing destinations, rises from Grebe Lake, in central Yellowstone, and merges with the Firehole River to form the Madison.

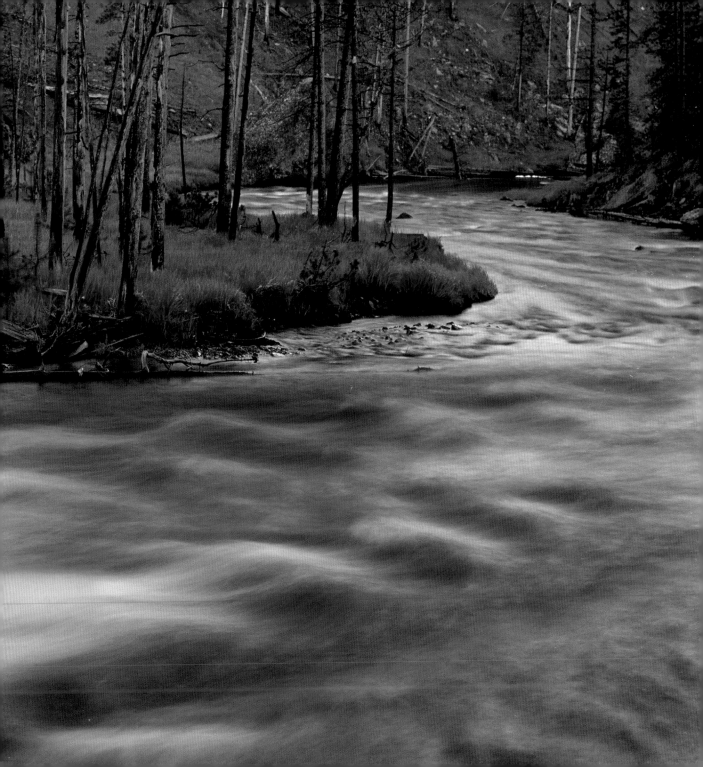

RIGHT: Described by a 19th-century visitor as "a charming picture, full of life and vigor," the 84-foot Gibbon Falls is located upstream from the confluence of the Gibbon and Firehole rivers.

OVERLEAF: The pronghorn is built for speed and endurance. As the continent's fastest land animal it can sprint at speeds of up to 50 miles per hour. Yellowstone's pronghorn population is found near the park's North Entrance and in the Lamar Valley.

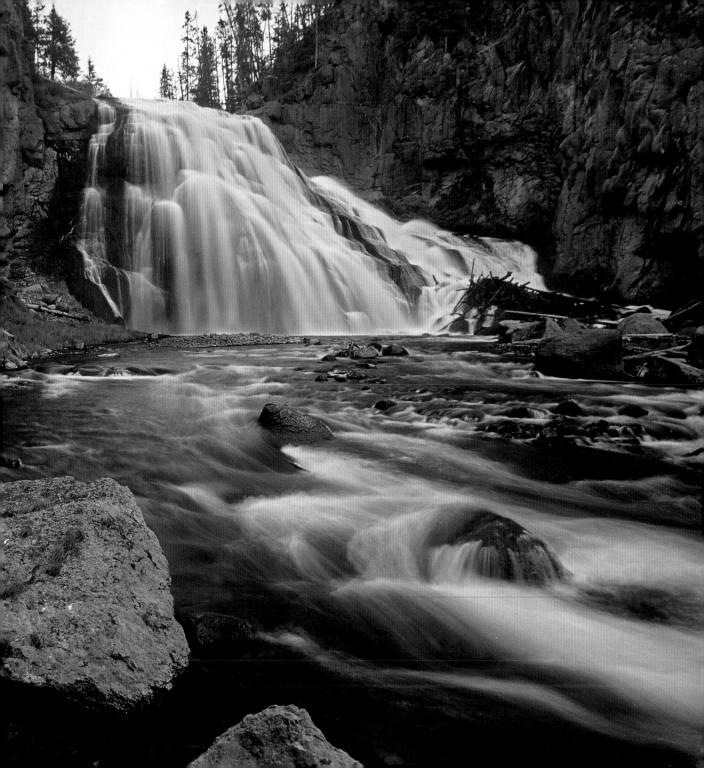

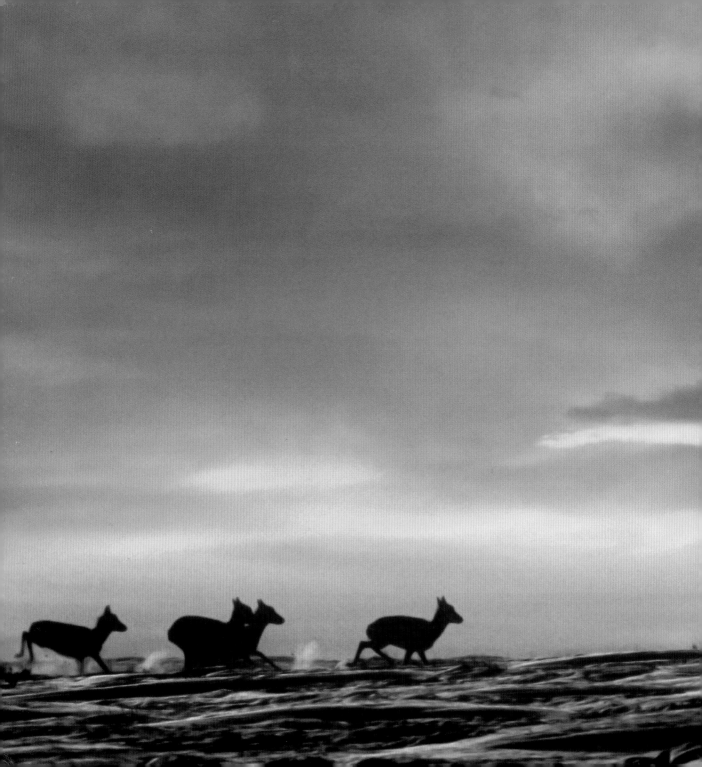

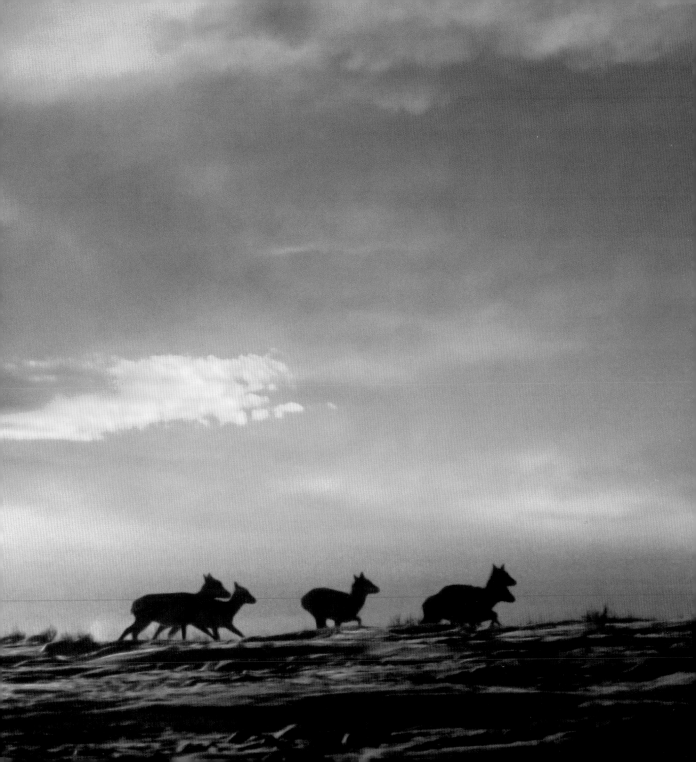

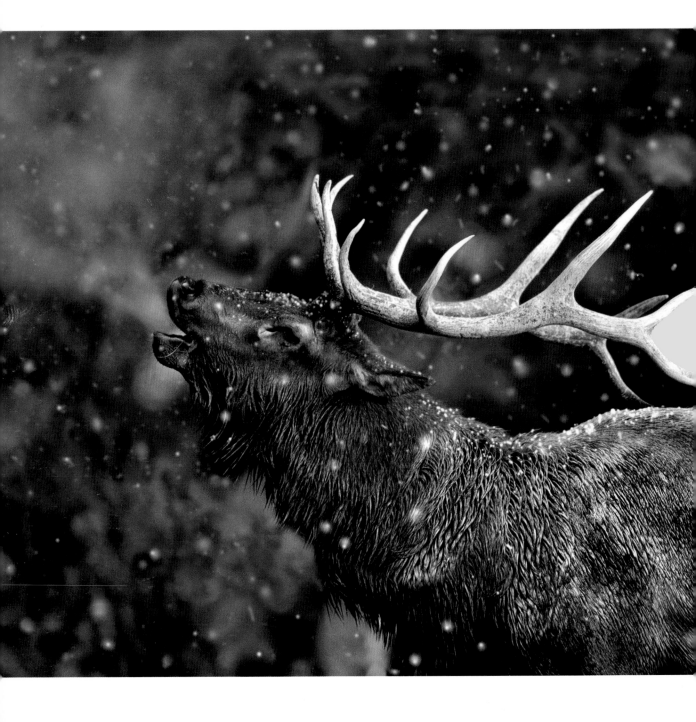

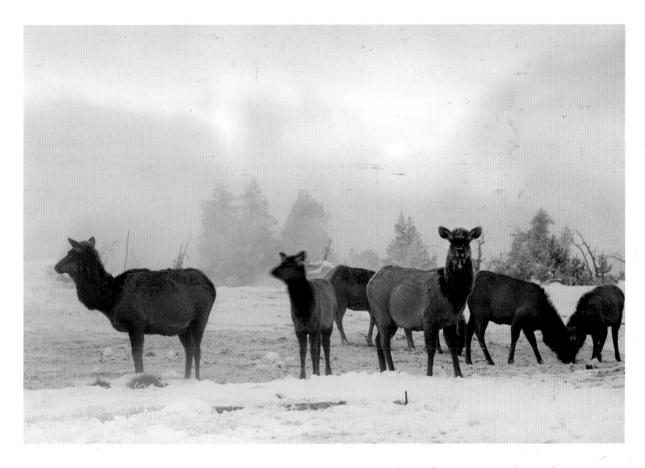

ABOVE: Yellowstone's hot pools are a favorite winter gathering place for wildlife such as these elk seeking relief from the cold.

OPPOSITE PAGE: During the rut, the mature bull elk bugles a mighty blast of power to get the attention of interested females and warn off competing males.

OVERLEAF: A bison bull can stand six feet tall at the shoulder and weigh 2,000 pounds, but even this massive beast seems almost insignificant in the expansive setting of the Madison River in winter.

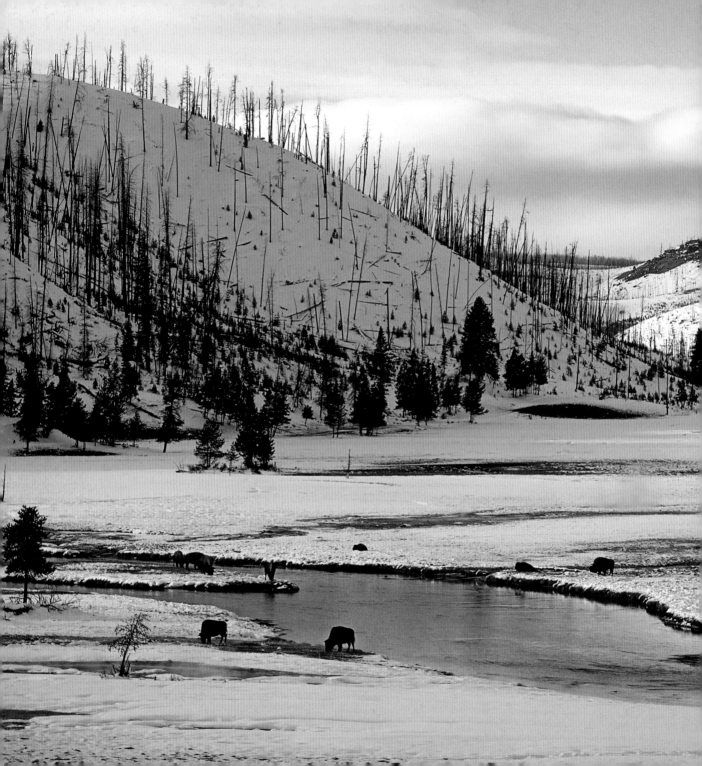

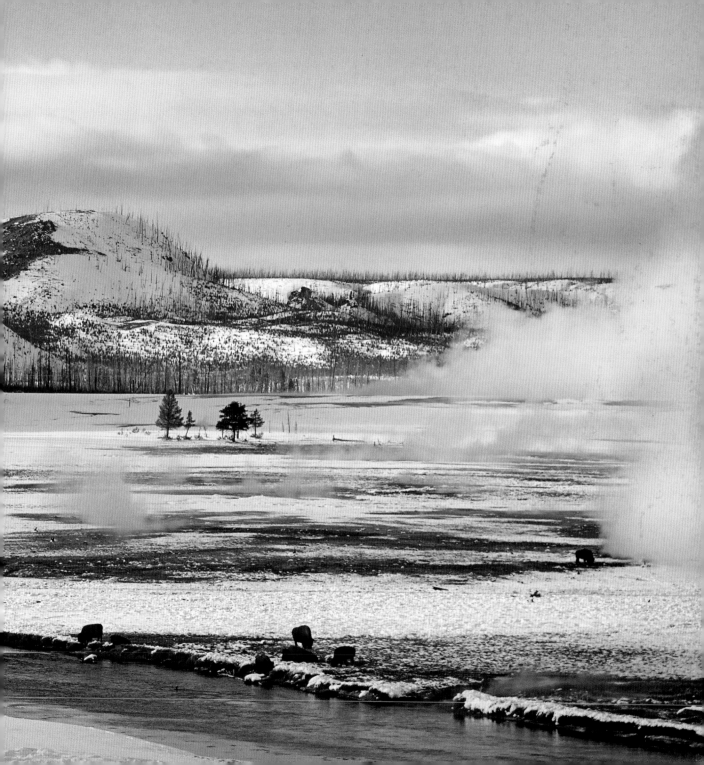

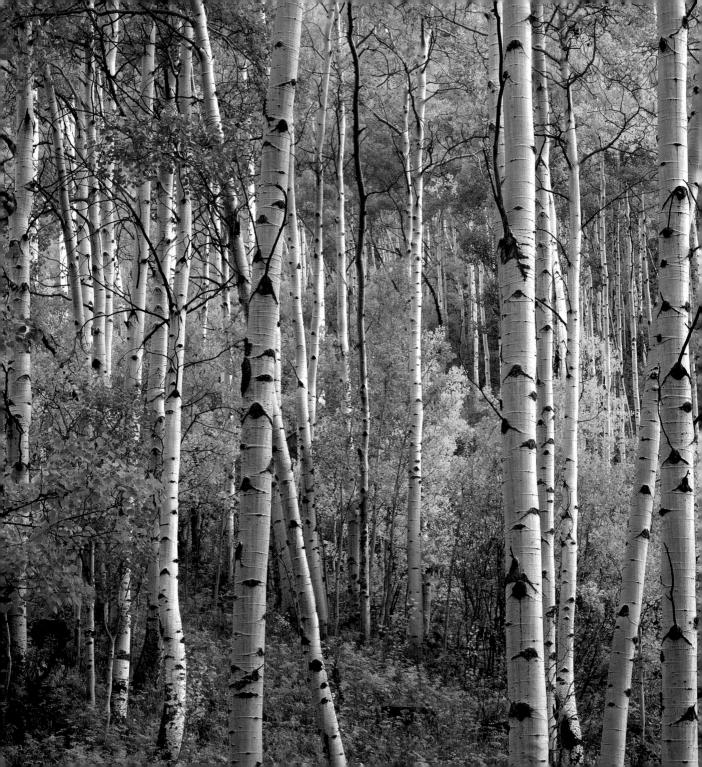

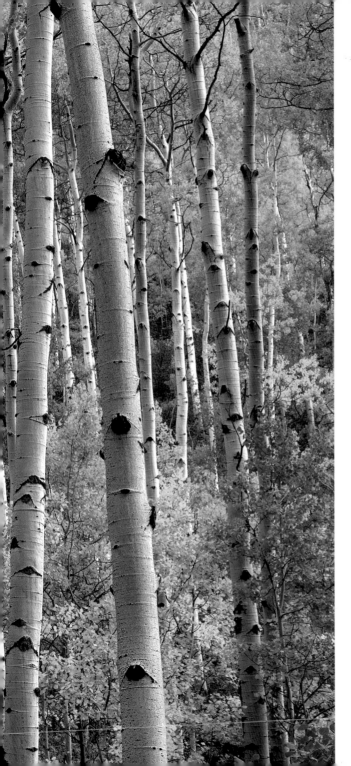

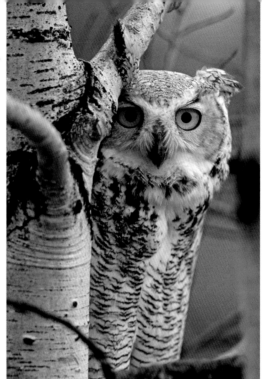

ABOVE: A nighttime hunter, the great horned owl uses binocular vision and excellent hearing to detect small mammals on the ground.

LEFT: Thanks to a generous root system, the quaking aspen is one of the first species to emerge after a forest fire has blackened the earth.

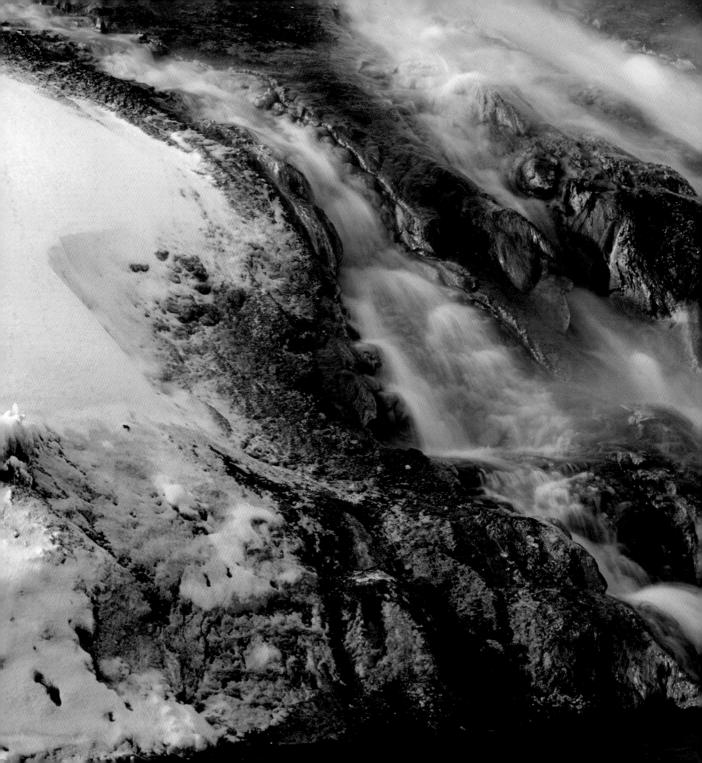

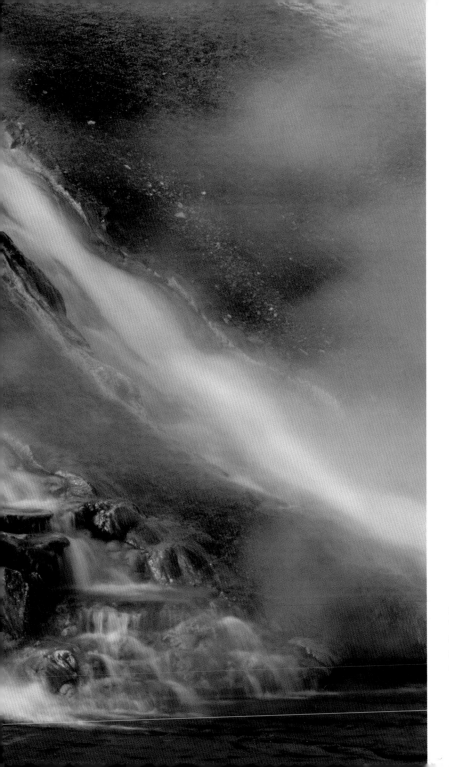

LEFT: Runoff from one of the Upper Geyser Basin's many geysers rushes into the Firehole River, raising the river's temperature and adding chemicals and minerals.

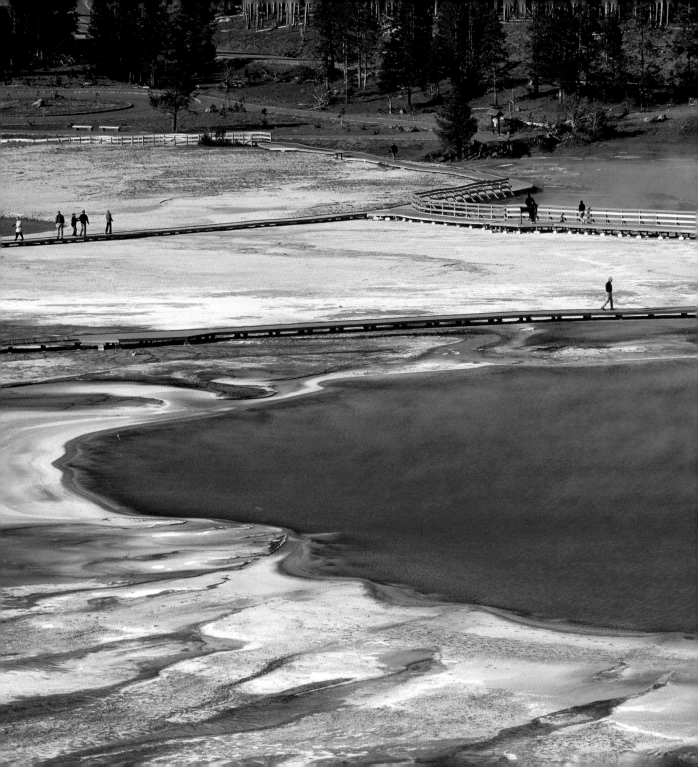

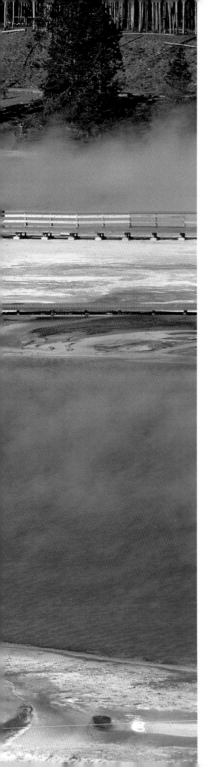

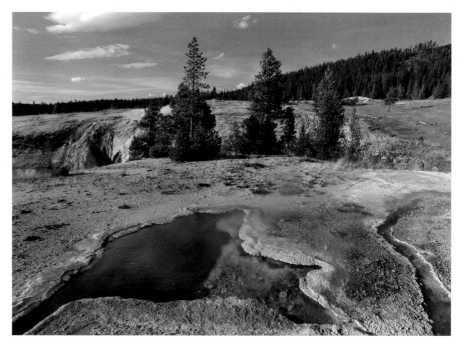

A wooden boardwalk keeps visitors at a safe distance from the largest hot spring in the United States, Grand Prismatic Spring, **LEFT**, in low-lying Midway Geyser Basin. The Grand Prismatic can reach temperatures of up to 188 degrees F, and the heat-tolerant single-celled cyanobacteria that edge the wide, deep pool produce an array of colorful pigments. Both the Upper Geyser Basin's Blue Star Spring, **ABOVE**, and the Grand Prismatic get their mesmerizing blue hue from sunlight reflecting off particles in the water.

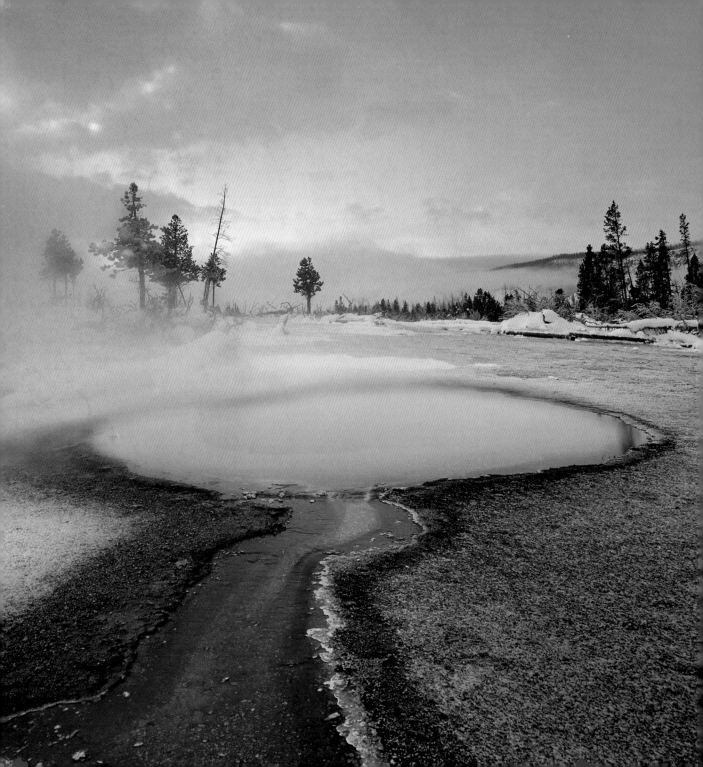

Banks of fresh snow cushion the shores of a park stream in winter, **BELOW**, while steam rises from a hot pool in Upper Geyser Basin, **LEFT**. The pool is edged with geyserite, a white-gray mineral deposited when spring waters bubble to the surface through silica-rich bedrock. The brilliant green of the runoff channel is produced by microbes that thrive in high temperatures.

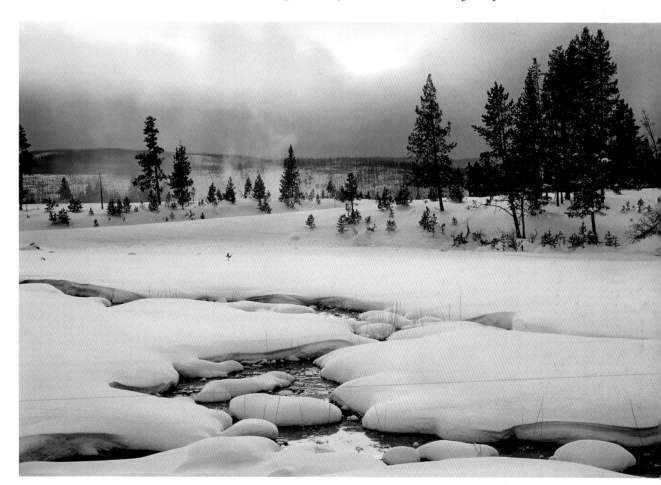

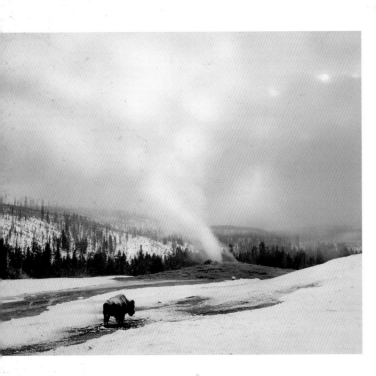

ABOVE AND RIGHT: Old Faithful, one of the Upper Geyser Basin's most reliable geysers, was famously named by members of the Washburn Yellowstone Expedition of 1870, "because of the regularity of its eruptions." The renowned geyser continues to impress park visitors roughly every 90 minutes.

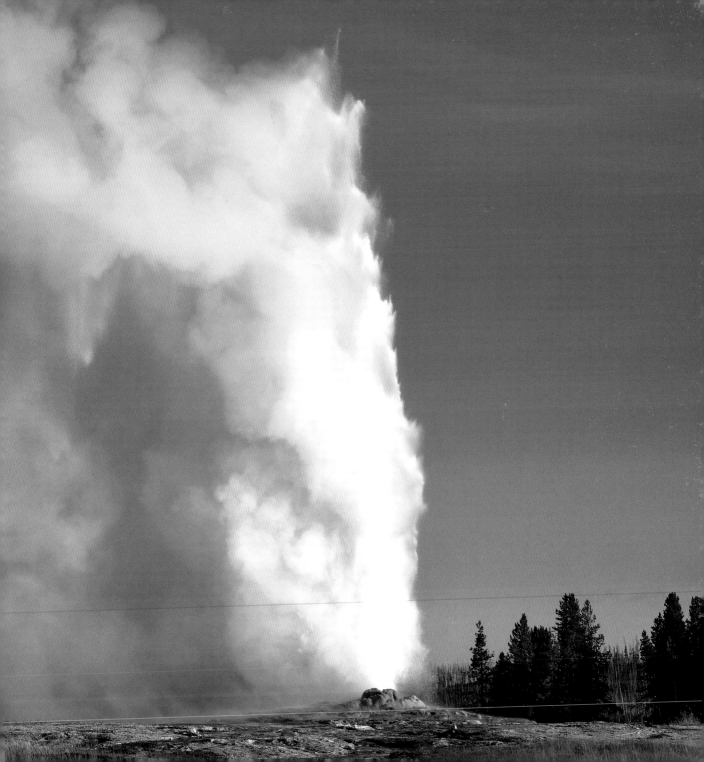

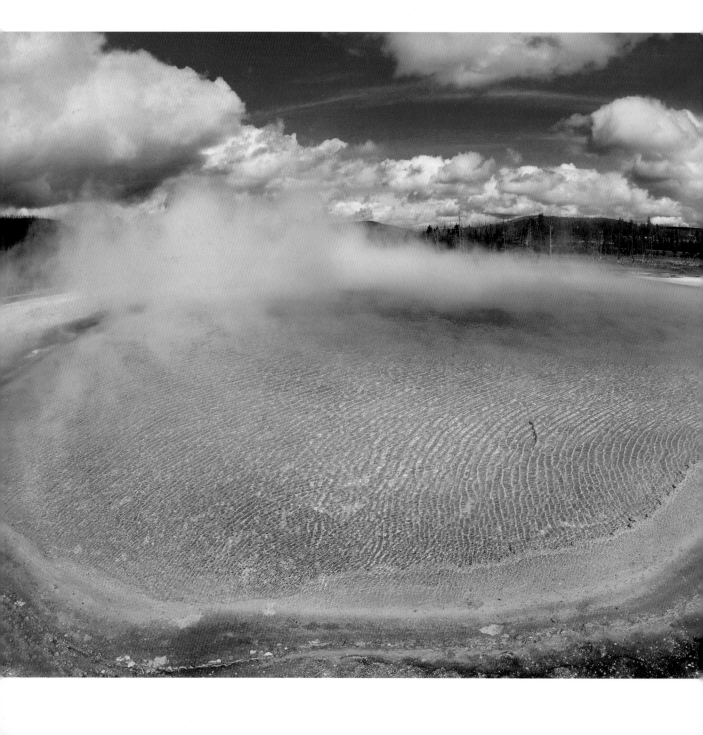

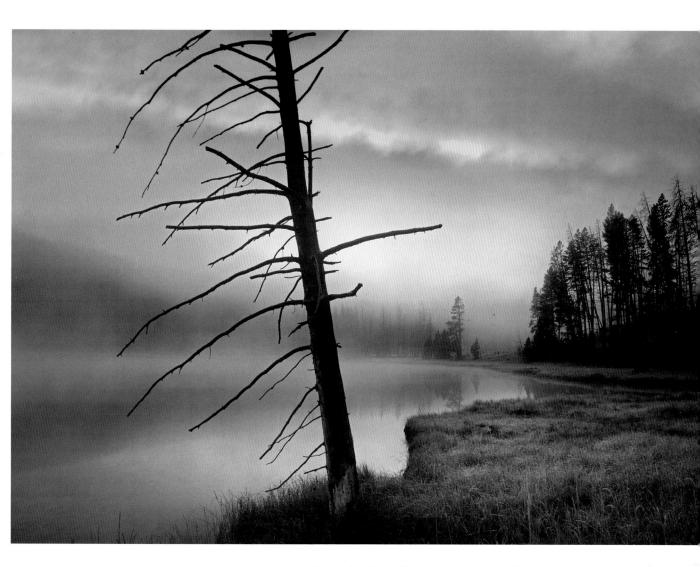

ABOVE: Big and unpredictable, Yellowstone Lake is the park's largest freshwater lake. Its size and unusual shape are the living legacy of the region's history of volcanism, earthquakes and glaciers.

OPPOSITE PAGE: The brilliant shallow waters of Sunset Lake shimmer in colors of lime-green and rust-orange produced by the cyanidium algae and cyanobacteria that flourish in its nearly boiling temperatures.

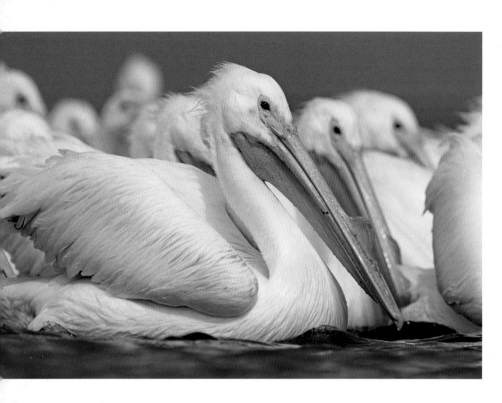

Bison and elk graze the grasses along the Yellowstone River, **RIGHT**, as it gently meanders through the Hayden Valley, a silty, marshy hotbed of plants and wildlife. Pelicans, **ABOVE**, geese, ducks and coyotes are also regular visitors.

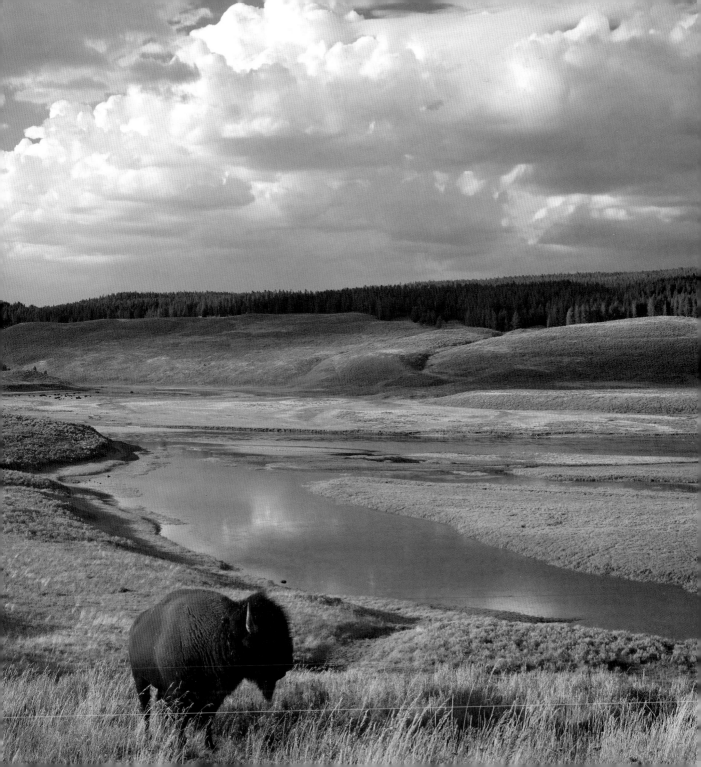

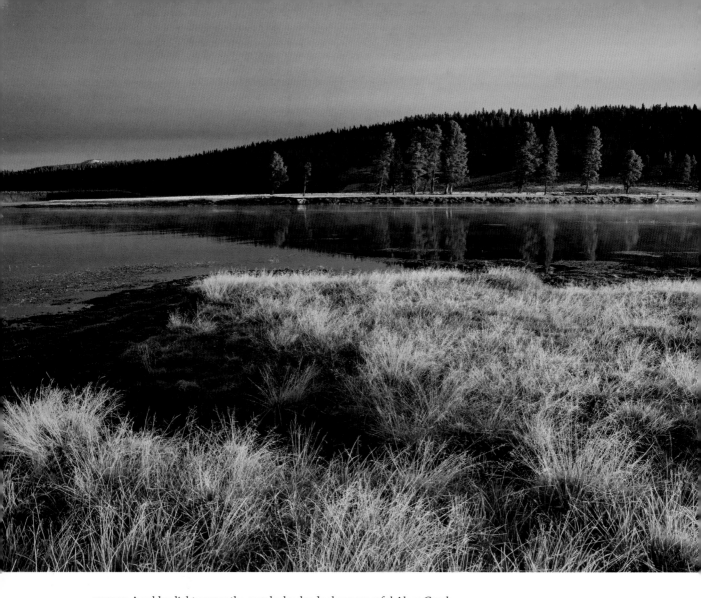

ABOVE: A golden light warms the marshy lowlands along peaceful Alum Creek. Running through the northern edge of the Hayden Valley, the creek is home to a wide range of the park's wildlife residents.

OPPOSITE PAGE: With the Absaroka Range in the distance, the dawn light is reflected in Alum Creek. Wetland areas, including streams, rivers, lakes and marshes, are critical habitat for Yellowstone's animal population.

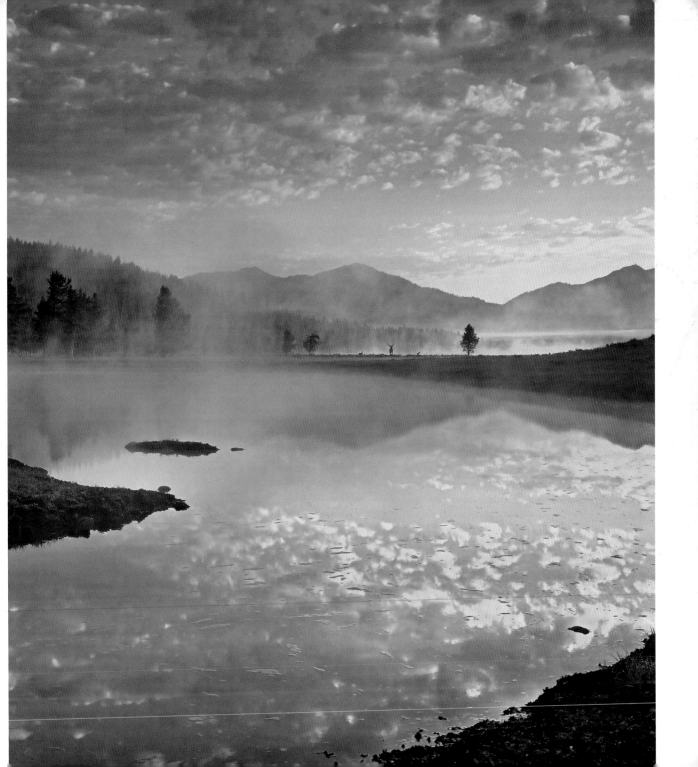

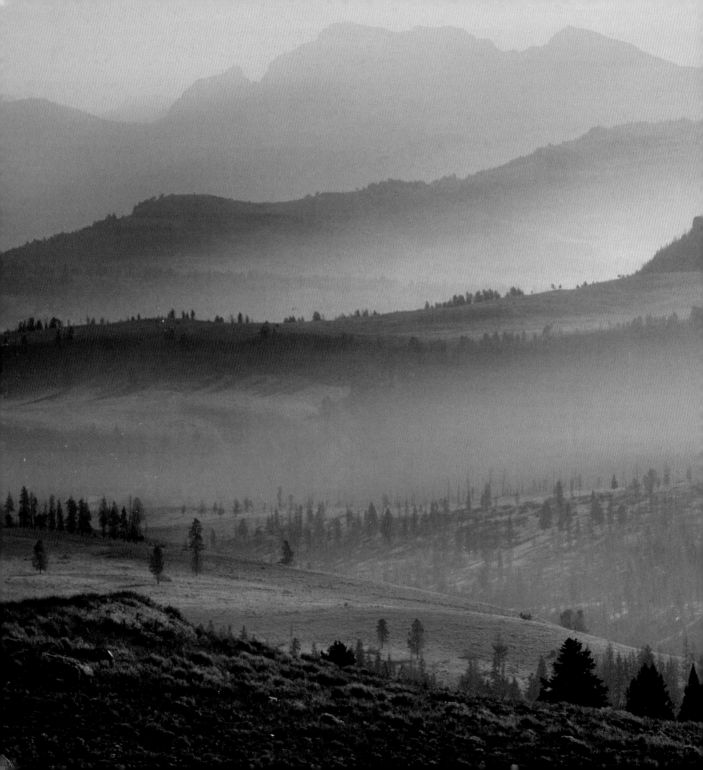

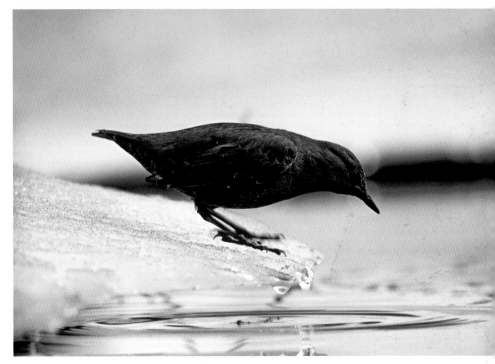

ABOVE: A resident of mountain regions, the sturdy, long-legged American dipper is adapted to wade and dive in icy, swift-moving streams in search of food. The dipper's beautiful song can often be heard over the rush of running water.

LEFT: The park's largest range, the Absarokas, stretches along its eastern boundary. These ancient mountains were formed by debris left from volcanic eruptions some 30 to 50 million years ago.

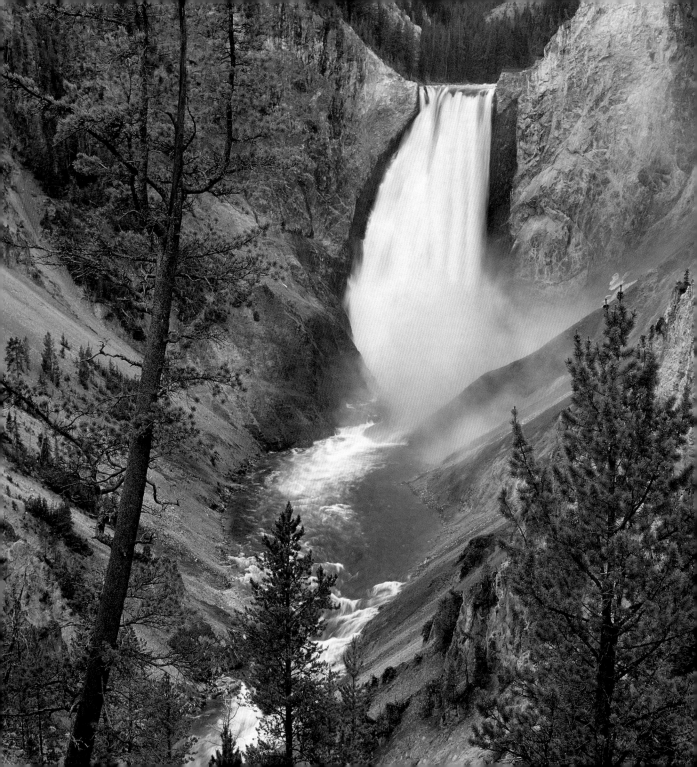

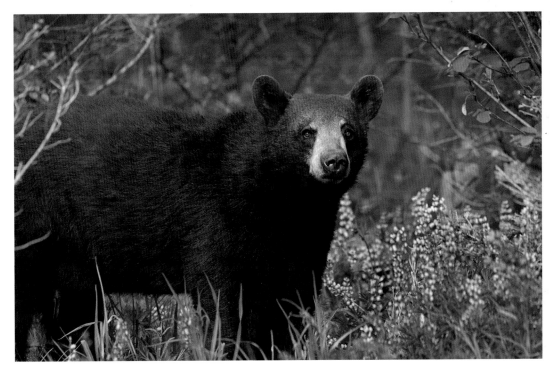

ABOVE: The black bear is one of two types of bears living in Yellowstone. This elusive park inhabitant has adapted to life in the forest but can occasionally be spotted in meadows and grasslands bordering the forest edges.

LEFT: After plunging over the 308-foot-high Lower Falls, the Yellowstone River roars through the spectacular 20-mile Grand Canyon of the Yellowstone.

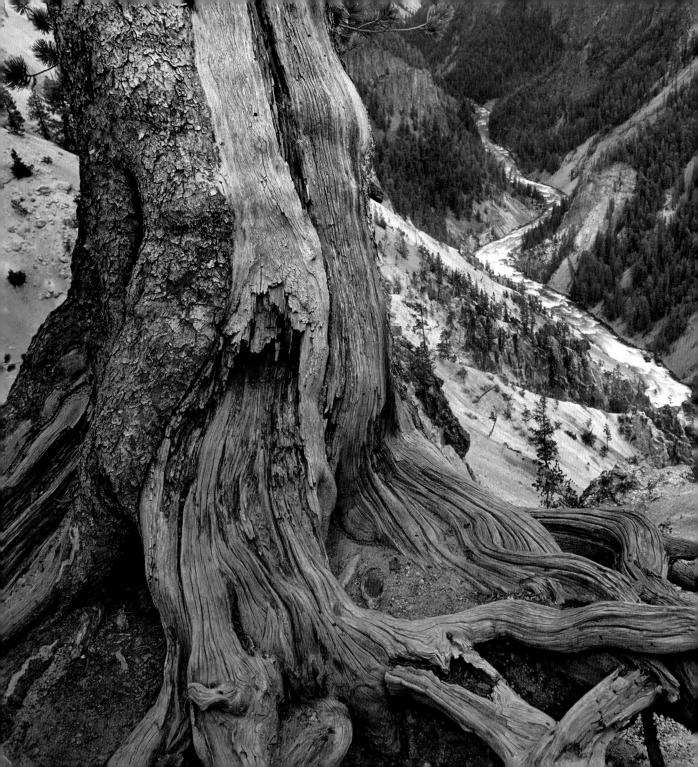

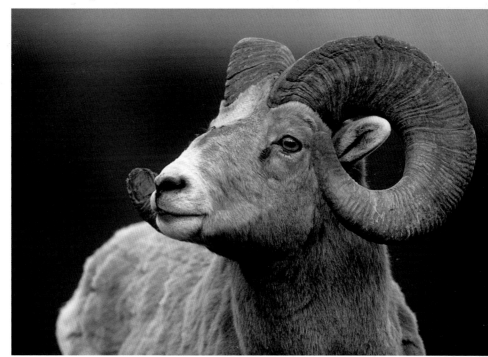

ABOVE: In autumn, the bighorn ram wields its sturdy horns in head-smashing mating displays that establish his dominance.

LEFT: British writer Rudyard Kipling described the Grand Canyon of the Yellowstone as "one wild welter of color" during his visit to the park in 1889. The canyon was created over thousands of years as the surging river and melting ice-dams eroded the canyon walls.

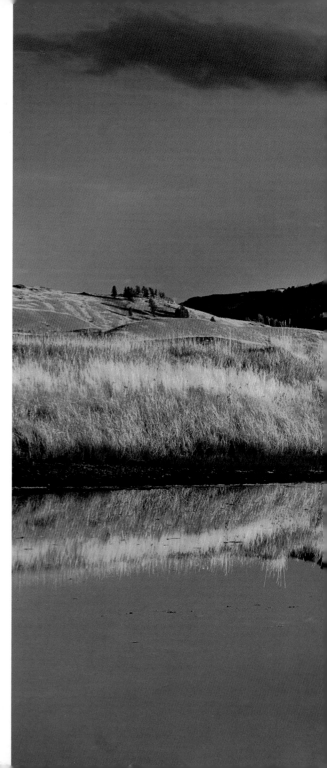

Slough Creek, **RIGHT**, eventually joins up with the Yellowstone River. The Slough Creek Trail offers hikers an excellent opportunity to explore wide-open spaces and spot solitary hunters like the red fox, **BELOW**, and fierce predators such as the grizzly and wolf.

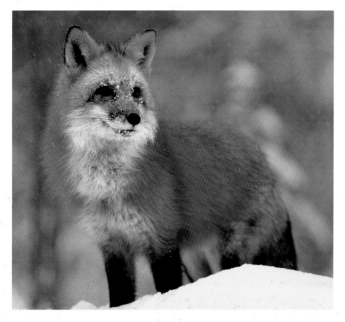

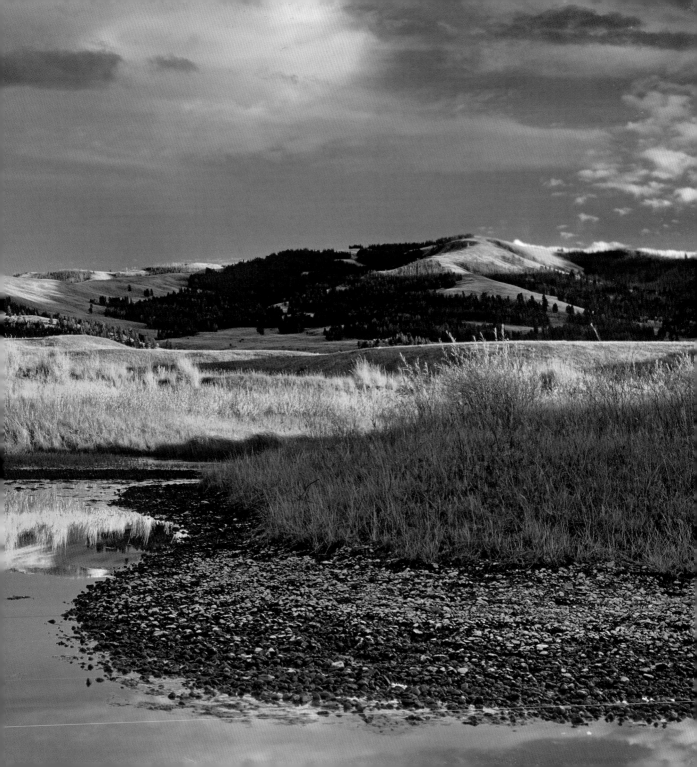

ABOVE AND RIGHT: Aggressively hunted by park rangers and area ranchers and farmers, the gray wolf was eventually extirpated from the park in the early decades of the 20th century. After years of debate, this controversial but essential predator was returned to Yellowstone, where its presence is helping to contain the once soaring elk population.

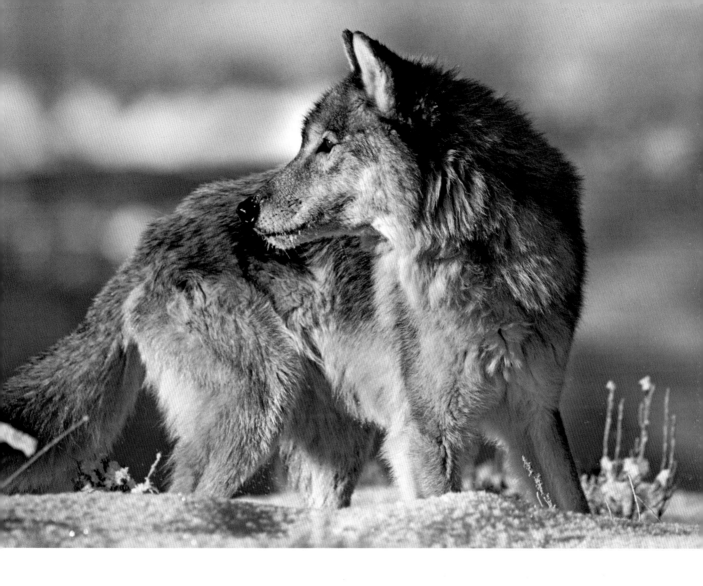

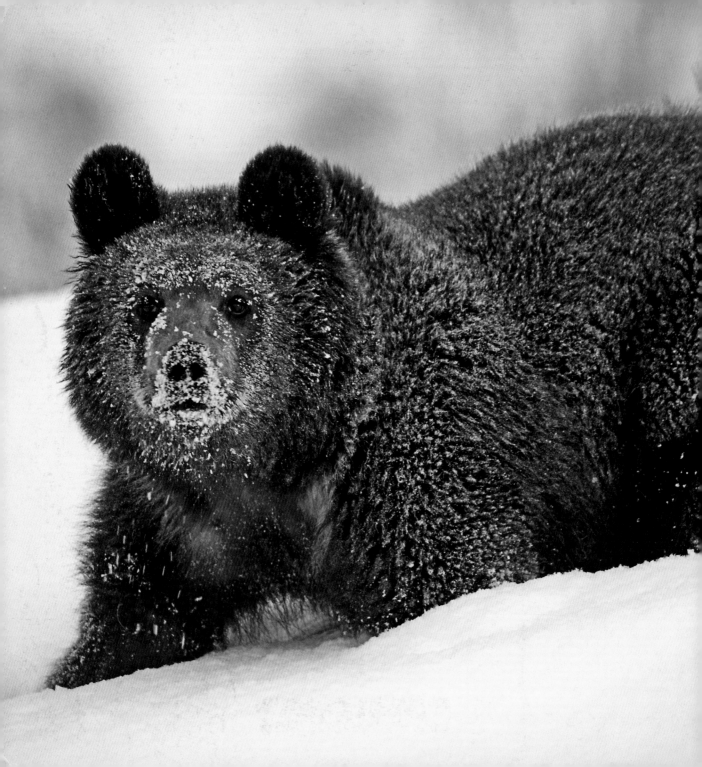

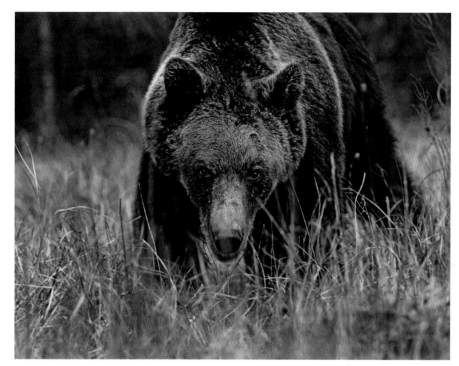

To endure the harsh Yellowstone winter, the grizzly cub, **LEFT**, packs on pounds in the fall, though he won't reach his full size, **ABOVE**, until the age of eight. Like the gray wolf, the grizzly is considered a keystone species in the Yellowstone ecosystem, influencing the life cycles of both plants and animals.